THE JOY OF PHOTOSHOP

Published in 2021 by Welbeck,
an imprint of Welbeck Non-Fiction Limited,
part of Welbeck Publishing Group,
20 Mortimer Street London W1T 3JW.

Editorial: Chris Mitchell
Design: Russell Knowles, Emma Wicks
Production: Marion Storz

A CIP catalogue record for this book is available from the British Library

ISBN 978 1 78739 898 6

Printed in China

10 9 8 7 6 5 4 3 2 1

THE
JOY OF
PHOTOSHOP

WHEN YOU ASK THE WRONG GUY FOR HELP

THE INTERNET SENSATION
JAMES FRIDMAN

WELBECK

INTRODUCTION

I didn't intentionally set out to become known for creating altered images. Years ago, I started producing photographic edits, just to amuse family and friends, and somehow, some of them ended up on the Internet. They struck a chord and people found them entertaining. They asked for more, and that's why I ended up making my Twitter account. Things just grew from there.

Obviously, at first, I was just trying to make people laugh, and that's still my main goal! I hope that, as you flick through this book, you get a lot of enjoyment from them, and hopefully a few proper laugh out louds.

However, as time went on, the amount of heart-breaking letters I received from people sharing their daily struggles became too much to ignore. One of the omnipresent issues teenagers and young people are facing today is self-acceptance, and there is an ever-growing pressure from society to fit into non-realistic standards imposed by means of mass and social media. Statistically, the majority of teenagers are not satisfied with how they look and how they are perceived by society and their peers. This dissatisfaction exposes their fragile psychological mechanisms to a wide range of mental disorders.

The Internet today is flooded with heavily retouched – at times to the point of absurdity – images of young people, and celebrities which are made to be perceived by others as the definition of "ideal" and "perfect".

Those images are deceitful and act as a catalyst for various mental-health related issues among the younger generation. It is important for young people to understand that "ideal" and "perfect" do not exist, and all attempts to pursue such are detrimental. As a result, I strongly believe that cosmetic and apparel companies must be banned from digitally manipulating the images they use in advertisements of their products and services.

My work, and this book, is an attempt to show that you can have fun with Photoshop without taking yourself too seriously. Young people shouldn't feel the need to present their lives and their bodies as flawless. Everyone has imperfections, and that makes them human. This book is a celebration of that.

James Fridman, 2021

SOCIALLY DISTANCED BESTIES

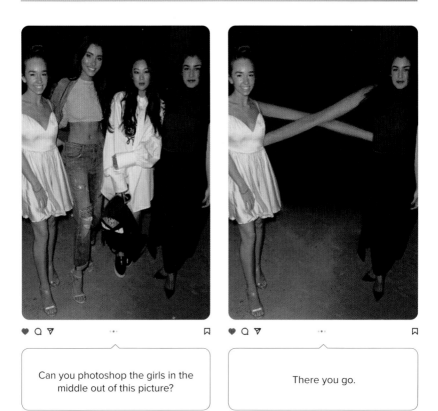

Can you photoshop the girls in the middle out of this picture?

There you go.

BABY FACE

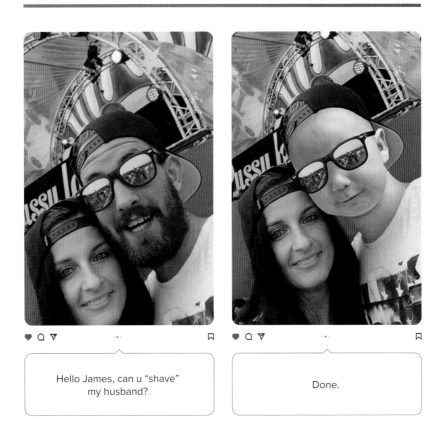

Hello James, can u "shave"
my husband?

Done.

BAD BOY WHAT YOU GONNA DO

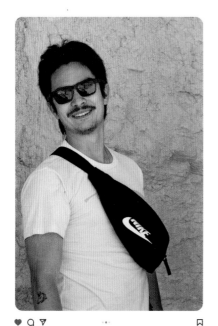

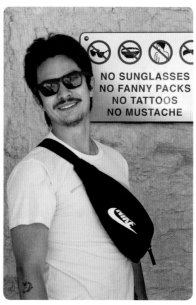

Hi James, can you make me look like a bad boy?

The police are on their way.

ADULTING

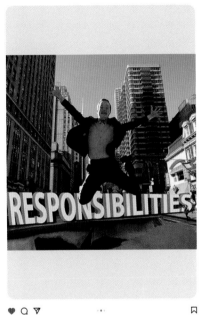

Hey James, could you add some drama to this photo, give me something to jump away from?

Welcome to adulthood.

DOMINOS IS THE CLASSY CHOICE

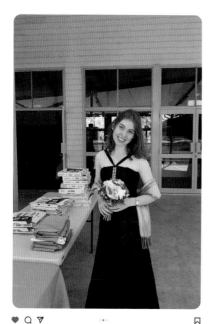

Hi James, is there any chance of removing the pizzas from the background so the picture looks a bit more classy? Thank you!

Hurry up.

EVERYTHING IN PERSPECTIVE

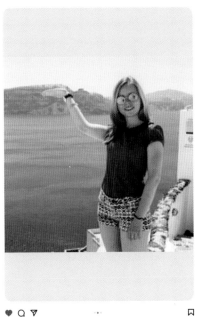

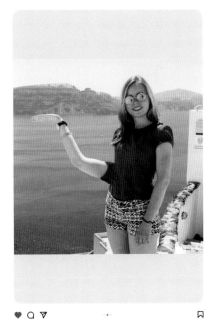

Hey Jamie! Can you please adjust this picture in order to make me look as if I am holding that cliff? Thanks!

Sure.

POLAND MY HOME LAND

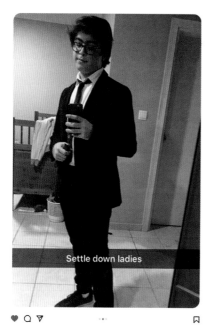

Settle down ladies

Hi Jamie, can u polish this pic to help me get the ladies?

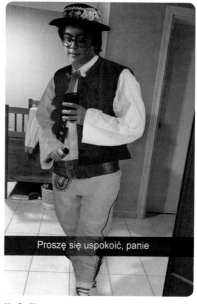

Proszę się uspokoić, panie

Tak.

THE RARE SEA-GIRAFFE

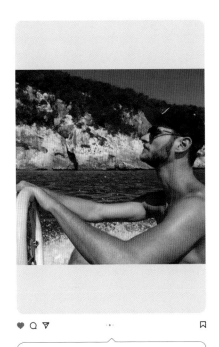

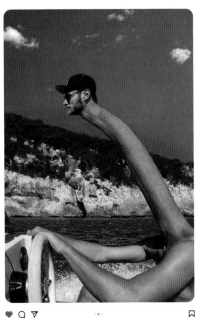

Hey Jamie! Please can you shop my picture? All my friends say that I have a neck like a giraffe.

Your neck is fine.
This is the giraffe neck.

AT ONE WITH NATURE

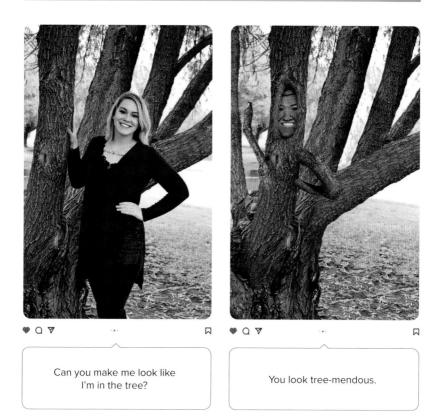

Can you make me look like
I'm in the tree?

You look tree-mendous.

TERRIFYING THOMAS

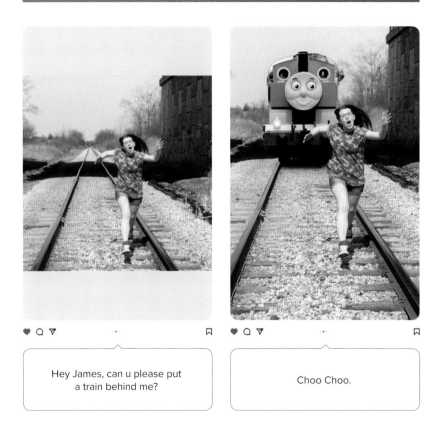

Hey James, can u please put a train behind me?

Choo Choo.

THE EVOLUTION OF MAN

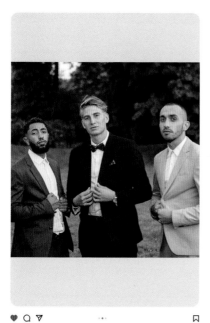

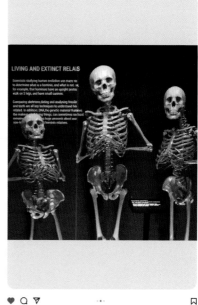

Hi James, I love this picture of my best friends and I but can you please make us stand in a museum instead of in nature. Thank you very much!!

Sure.

TWISTICORN

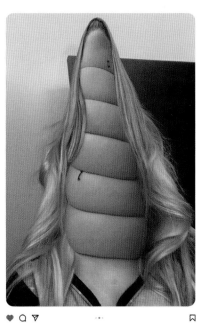

Can you make me into a unicorn? Please, it would make me so fucking happy.

As you wish.

FRECKLES ARE CUTE

Hey James, could you just blur out the freckles on my face, thanks!!!

Don't blur out something that is part of you, something that makes your appearance so unique. Freckles actually make you look very cute.

CAN YOU DIG IT?

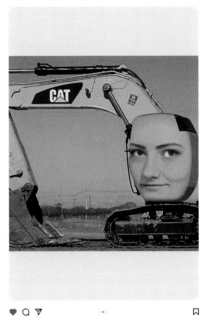

Can you plsss make me into a cat, it is my one and only dream.

No doubt.

20/20 VISION

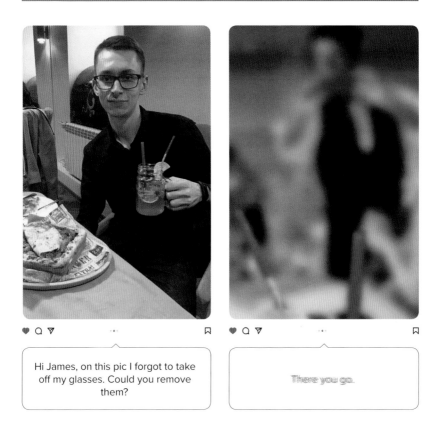

Hi James, on this pic I forgot to take off my glasses. Could you remove them?

There you go.

BENJAMIN BUTTON

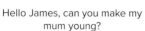

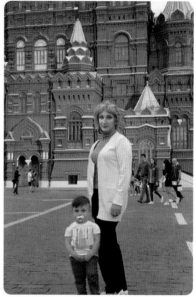

Hello James, can you make my mum young?

Awww.

OFF TO WORK WE GO

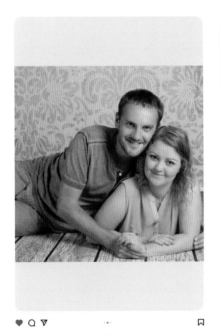

♥ Q ▼　　　··　　　🔖

Hi James, can you please make it look as if I'm not standing in a hole in the floor?

♥ Q ▼　　　··　　　🔖

Sorted.

A GALAXY FAR, FAR AWAY

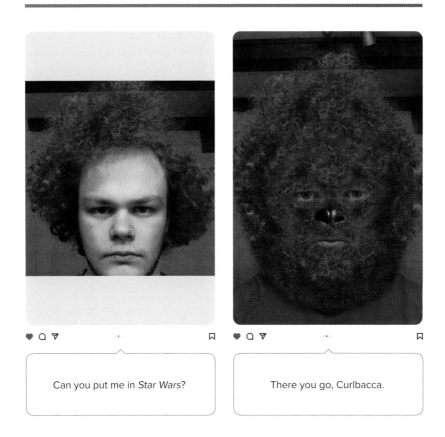

Can you put me in *Star Wars*?

There you go, Curlbacca.

WEDDING TRAIN, NOT CAR

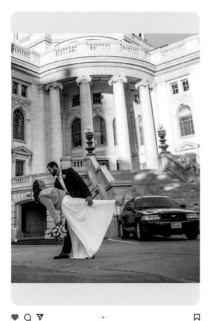

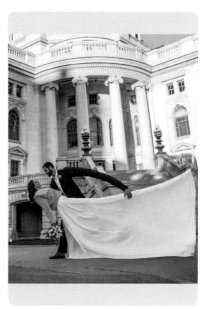

Hi James, I love this picture of my husband and I, but I wish the car was not in the picture.
Can you help?

Congrats!

SPACE TRAVELLER

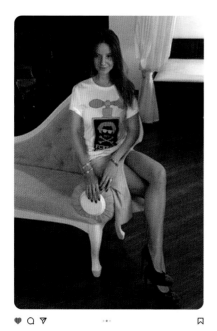

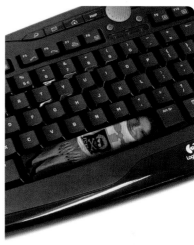

Hi James, can you fulfill my dream and photoshop me into space? Thanks!

Of course.

MAN'S BEST FRIEND

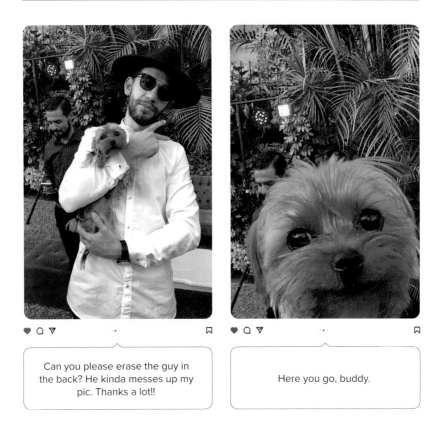

Can you please erase the guy in the back? He kinda messes up my pic. Thanks a lot!!

Here you go, buddy.

PERFECT TIMING

Hi James, would you be able to make the girl second from the right higher off the ground? Thanks!

See ya!

HARDCORE KNITTING

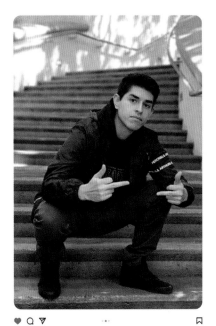

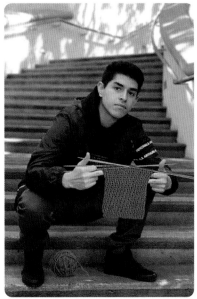

Hey James! I really like this picture of myself but I don't like that I was flipping off the camera. Can you make it look like I'm not giving the middle finger and do something else with my hands, thank you!

Nana will be proud.

GROWTH SPURT

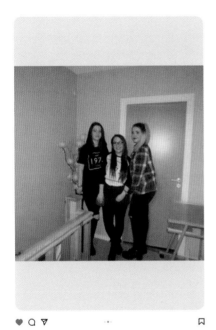

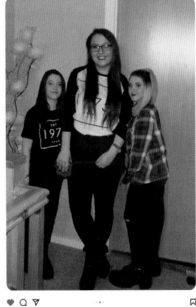

Hello James! Could you make me taller in this photo?
I'm in the middle.

What's the weather like up there?

BEARING A GRUDGE

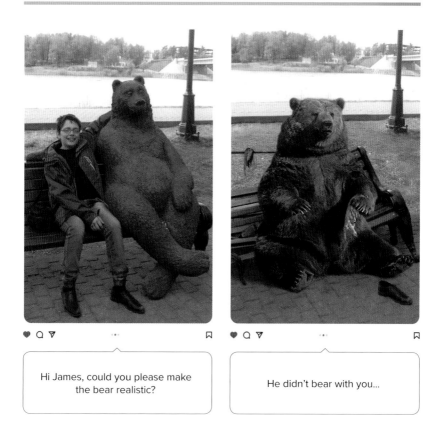

Hi James, could you please make the bear realistic?

He didn't bear with you...

COOL BIRTHMARK

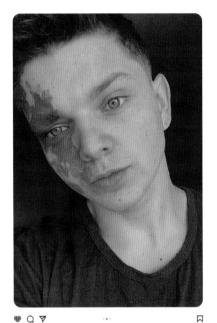

Hey Jamie, I'm a fan of your work and I hope you can help me. See my face? It's my birthmark and it's been 20 years with it. Can you make my face have just one colour or make it look better?
I know you'll help me, thanks soo much.

Our differences and imperfections make us human. Don't hide something that makes you so unique, something that's been part of you since you were born. Accept it, and so will others. P.S. Your birthmark looks pretty cool to be honest.

MIRROR IMAGE

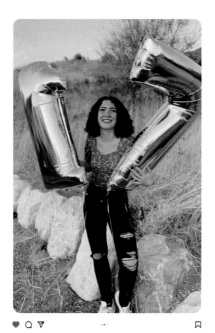

Hi James, I love your work! I love this picture but my stupid self couldn't hold the 1 the right way. Could you fix it?

Fixed.

BEAUTY QUEEN

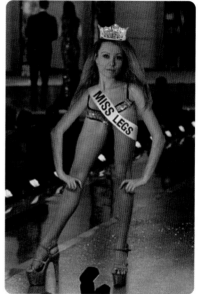

Hey Jamie, from this photo session for my boyfriend, he only likes my legs, haha. Can you make me miss legs like I am the best legs and nothing else, something to blow his mind? Thanxx!

This should blow his mind.

WHERE'S WALLY?

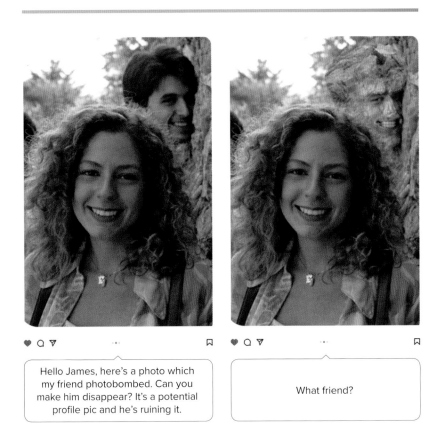

Hello James, here's a photo which my friend photobombed. Can you make him disappear? It's a potential profile pic and he's ruining it.

What friend?

IN PROFILE

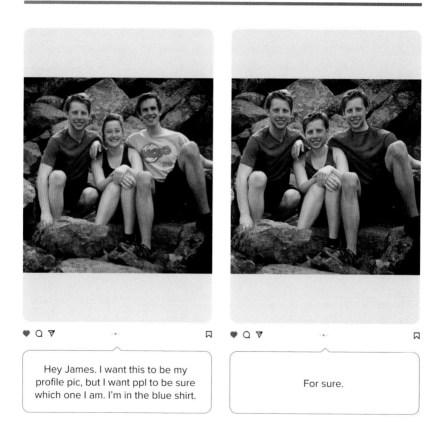

Hey James. I want this to be my profile pic, but I want ppl to be sure which one I am. I'm in the blue shirt.

For sure.

NO DIRT THERE

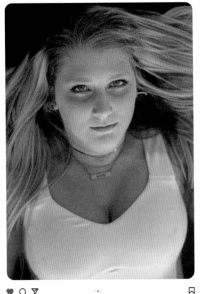

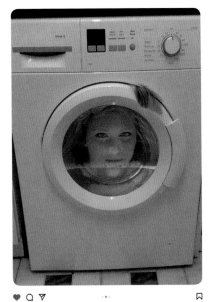

Hey James, so this is one of my senior pictures and I wanted to make sure you could tell I was in the water, but it just looks like I'm laying in black dirt... Is there any way u could make it look like I was under water more?

"I tried to scream, but my head was underwater."

GUARDIAN OF THE GALAXY

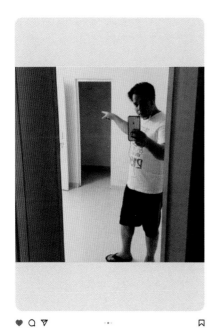

Hey, please make me stand on Mars pointing at earth.

Sure.

THEY DON'T ALL WEAR CAPES

Hi James, could you please make me a real superhero? I'd love it.

*Marvel has left the chat.

HEAVY LIFTING

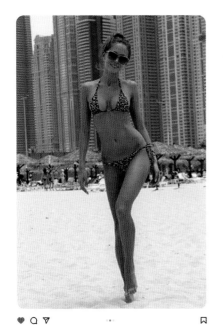

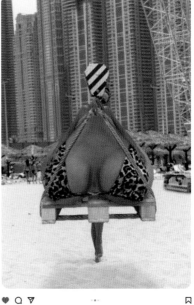

Hey, I want super big boobs, can u make it happen pls thnxxxxx

Hope this helps.

OUT AND ABOUT

Hey James! Would you be able to make me and the boys look like we are outside? Thanks!

You and the boys are outside.

SPRAY 4 SELFIE

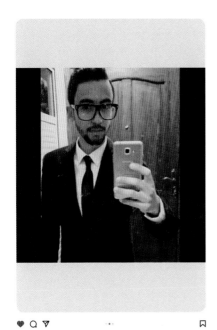

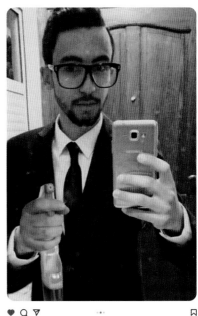

Hey man. The mirror was kinda dirty when I took this pic. Could you please do something about it?

Try this next time.

SIBLINGS ALWAYS SHARE

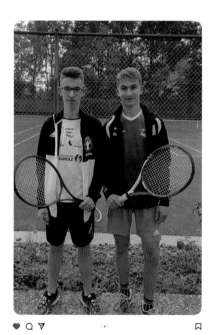

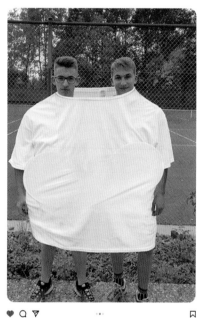

Hey James, can you please edit this picture so my brother and I wear the same t-shirt? Thanks!

Wimble-done.

WEASLEY TAKEOVER

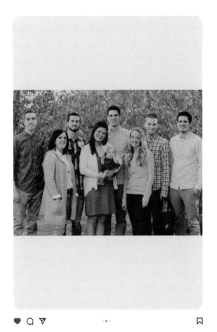

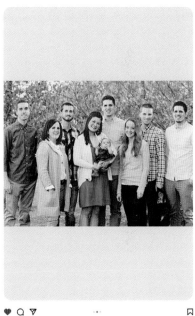

Hey James, can you help me fit in with my family? I'm the only redhead...

Your family is lit.

VITILIGO

I have a skin condition (vitiligo), just want 2 see if normal is prettier. Can u remove white spots plz?

Your skin condition doesn't make you less attractive. Do not let it ruin your confidence. People will see past it once you stop concentrating on it.

PEDICURED

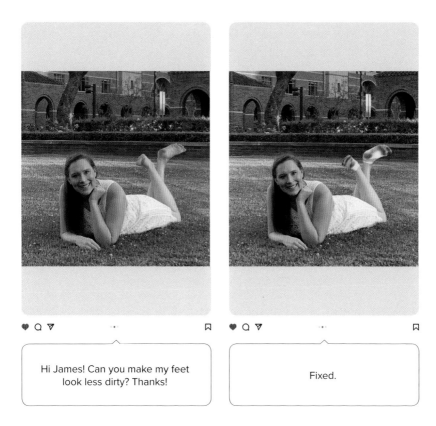

Hi James! Can you make my feet look less dirty? Thanks!

Fixed.

IT'S THE AFTER PARTY

Hey James, I'm the one making a triangle with my hands. Can u put Jay Z and Beyoncé on my left? Thanks.

Done.

ICE ICE BABY

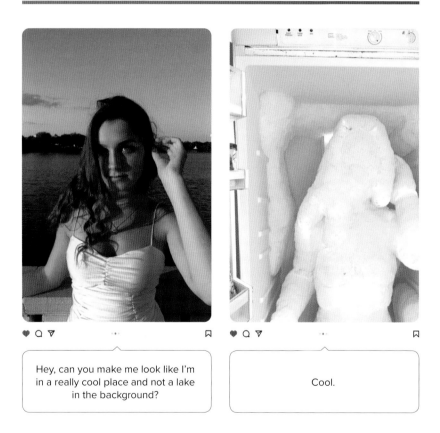

Hey, can you make me look like I'm in a really cool place and not a lake in the background?

Cool.

JUST TAKING A BREATHER

Hi James, could you make me look buffer?

Give this place a go when you wake up.

PIMP MY RIDE

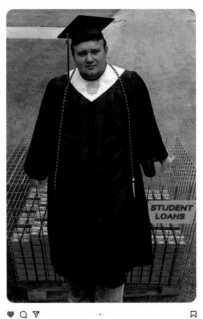

Can you change my car out for something a little more expensive? Thank you!!!

This should do it.

SPOT THE DIFFERENCE

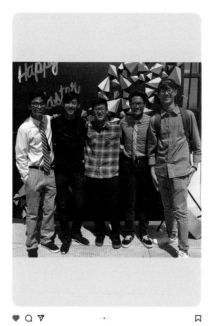

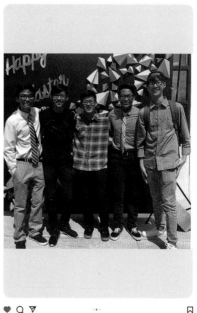

Hey James, can you photoshop us? Anything works.

Find 13 differences.

IT'S THERE FOR A REASON

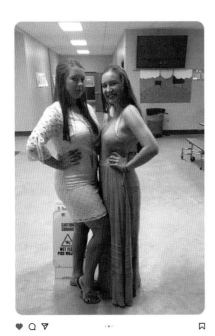

♥ ○ ▽ · · · ◻

Hey! Can you please make this picture look less awkward and edit out the wet floor sign? Thanks!

♥ ○ ▽ · · · ◻

Be caref... Oops.

LIVING THAT DIGITAL LIFE

Hey James, can you please photoshop me into a party so I look like I have a social life? Thanks!

Social life in 2021. Sorry to disappoint you.

HAPPY BIRTHDAY

Can you make us look older and at a party or something?

Surely, darling.

HIGHLIGHT YOUR FEATURES

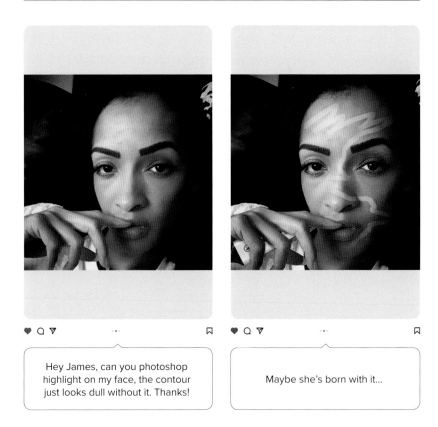

Hey James, can you photoshop highlight on my face, the contour just looks dull without it. Thanks!

Maybe she's born with it...

CLEAN SWEEP

Brooooo, can u take out the broom?? Ty.

Sure.

IN THE DOG HOUSE

Hey James, can you pet me in a Bugatti? I lied and told my friends I got one.

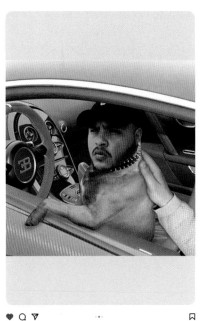

Good boy.

BE HEALTHY, BE YOURSELF

Hey Jamie! Love your work. I am very slender. I'm often mocked and asked if I'm anorexic, which I'm not, yet it's incredibly hurtful. Society thinks I'm too skinny and I have a very difficult time gaining weight. Any chance you could work your magic and help me see what I'd look like if I gained some weight? Thanks!

Society and media have no personal interest in you and your wellbeing. Sometimes even those close to you might not know what's best for you.
Be healthy and be yourself.

MYSTIC MISCHIEF

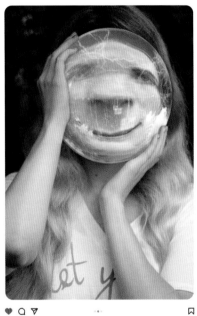

Hi! Can you somehow adjust my hands and make it look like I'm holding a glowing orb/ball? Thank you.

See the future?

STAYING WOKE

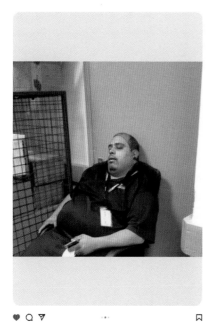

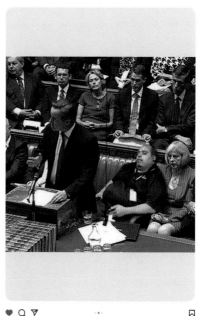

Hey! I heard you can make magic happen! Can you make him productive?

He is now as productive as everyone else around.

PHOTO SHOPPED

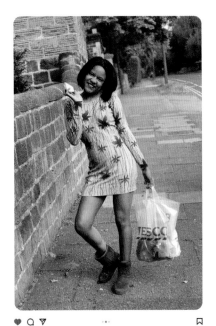

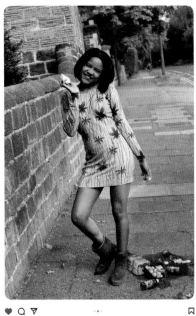

Hey Jamie, I love this picture, can you please get rid of that Tesco bag for me? Thanks a lot!!!!

If you say so.

KAYAK AL DENTE

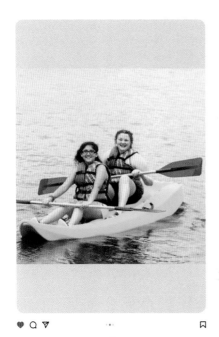

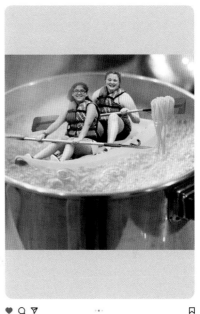

KARAOKE CAR

Hey, can you help my brother not look tired? Thanks.

Tired?

APRÈS SKI

I made a weird fist in this picture, can you add something in my hand? I'm the girl in the beige dress.

No sweat.

BACK TO THE START

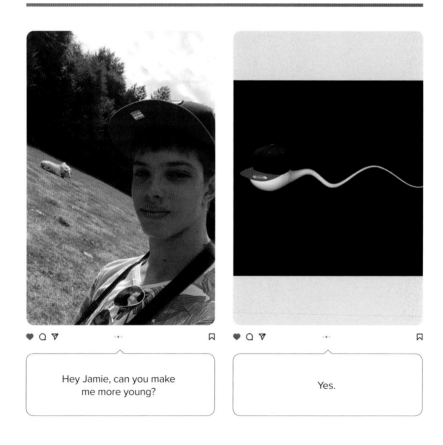

Hey Jamie, can you make me more young?

Yes.

WIND YOUR LEG IN

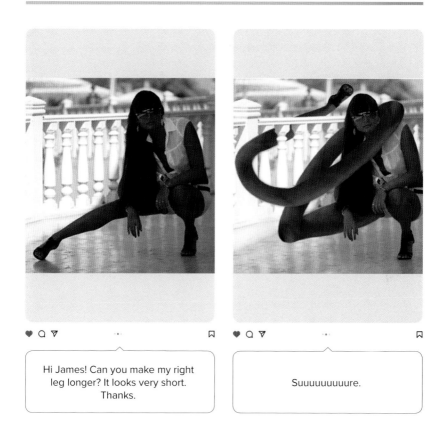

LEAF IT OUT

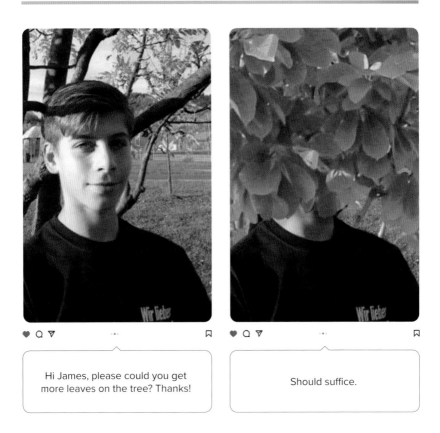

Hi James, please could you get more leaves on the tree? Thanks!

Should suffice.

DRY HUMOUR

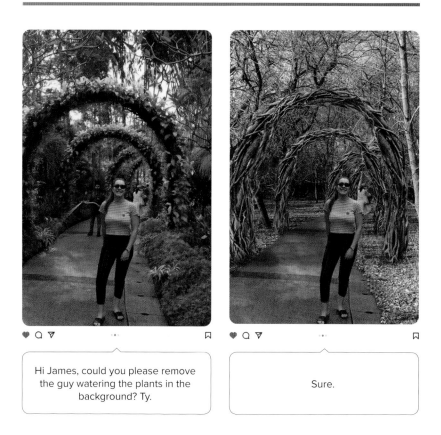

Hi James, could you please remove the guy watering the plants in the background? Ty.

Sure.

WHAT A MUPPET

I love your photoshop work. Could you please make it so my boyfriend's armpit hair doesn't show? It's grossing me out. Thanks.

Hair you go.

GRATE IMPROVEMENT

Hi James, we love one boy and I want to send this photo to him, can you make it that I look grate and other girl in black shoes look bad. Sorry thanks.

The Gratest.

HAPPY THE WAY YOU ARE

Can you make me look thinner please... I'll never be thin and I want a picture I can be proud of...

You can't be proud of something you didn't achieve. And if you are healthy and happy the way you are, why change?

DRESSED UP FOR THE COMMUTE

Hi James! I really like this photo of myself but I feel like my hand is messing the whole pic up! Can you remove it? :) x

It might come in handy.

UTTERLY TERRIFYING

Hi, please can you make it so my friend is running from something scary? Thank you.

They see you.

THE BALD TRUTH

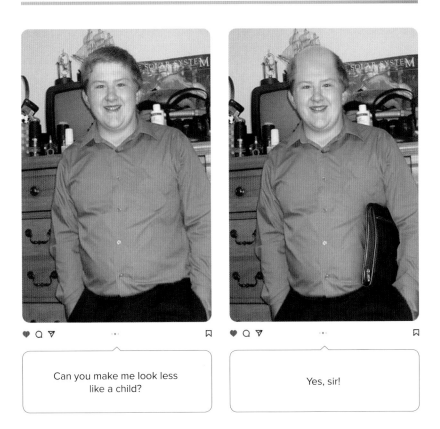

Can you make me look less like a child?

Yes, sir!

NOTHING BUT THE TOOTH

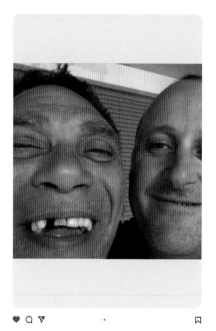

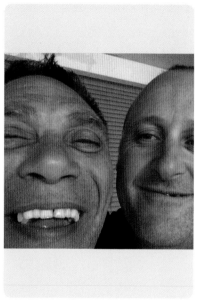

Hi James, please could you hide the gap in my father-in-law's mouth... with thanks.

Thure thing.

FORE AMBULANCES PLEASE

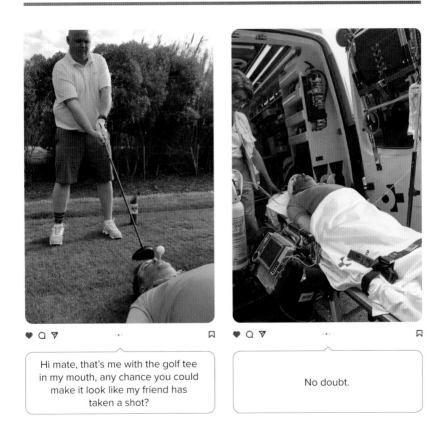

Hi mate, that's me with the golf tee in my mouth, any chance you could make it look like my friend has taken a shot?

No doubt.

WEDDING CRASHER

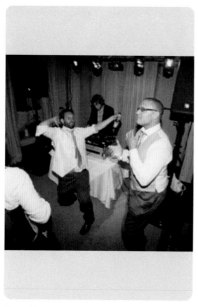

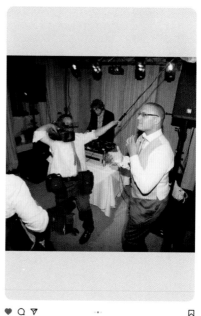

Hi Jamie – this is Jim ruining a great wedding photo. Can you make him look more formal please?

Jim is doing his job.

LOVE IS BLIND

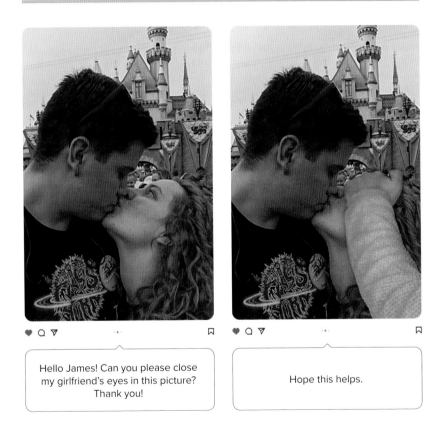

THIRD WHEELING

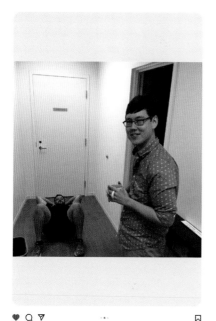

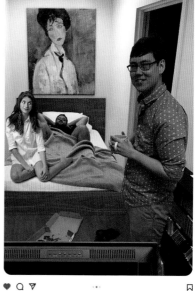

Hey James. Can you put my friend in a less awkward pose? Thanks.

You look uncomfortable.

MIRROR MIRROR

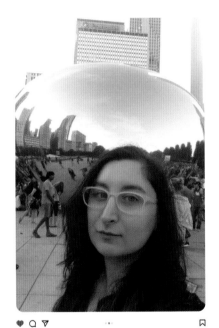

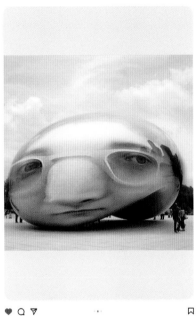

Jamie, can you make my face reflect in the sky reflection on the bean? Thanks.

There you go.

LOSING YOUR HEAD

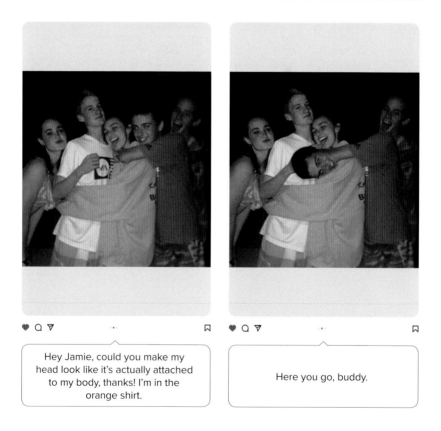

Hey Jamie, could you make my head look like it's actually attached to my body, thanks! I'm in the orange shirt.

Here you go, buddy.

FINGER LICKIN' GOOD

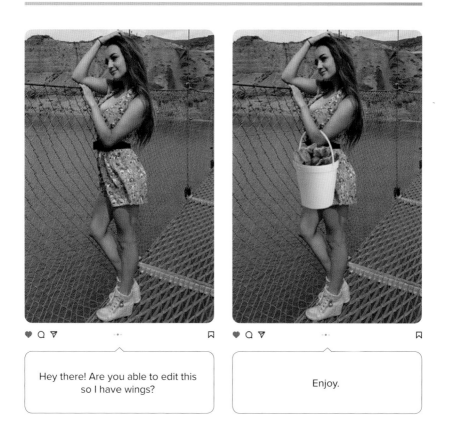

Hey there! Are you able to edit this so I have wings?

Enjoy.

PUBLIC SERVICE

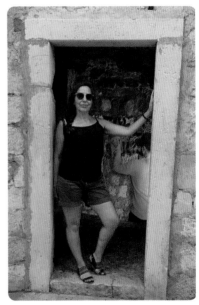

Hi James! I love your photoshop work! Would you clean the stone wall for me? Thanks!

I'm on it.

BULLYING

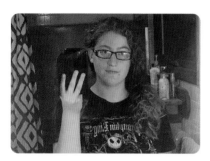

♥ ◯ ✈ ⸱ ⸱ 🔖

Dear James,
I'm really sorry to bother you, but I'm always being made fun of for something... especially some of my team mates and class mates. Whether it's about something I said or wore, or even just how I look (hair, teeth, acne, weight, etc.). It's been making certain things even worse than they've been in the past...
So, I was wondering if you had the time... could you maybe make me look somewhat better? Again, I'm really sorry to bug you with this as I'm sure you have many more requests that are more important.
Sorry again.

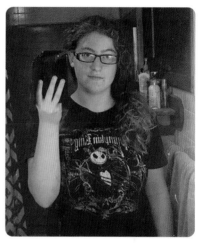

♥ ◯ ✈ ⸱ ⸱ 🔖

You shouldn't feel the need to make yourself "look at least somewhat better" to satisfy standards set by a bunch of pitiful and insecure bullies who diminish others in order to raise themselves up.
What others think of you depends on how you see yourself. Focus on something you can do better than others, it will help you build confidence and make you stronger.

IDENTICAL TWINS

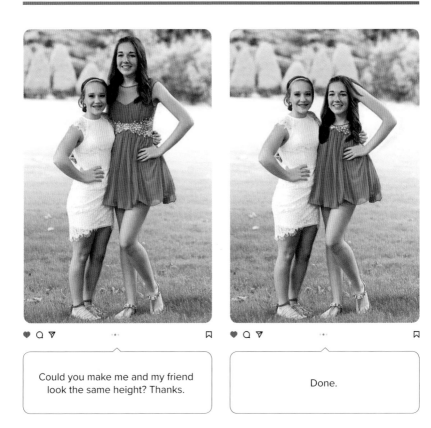

Could you make me and my friend look the same height? Thanks.

Done.

WALKING IN WATER

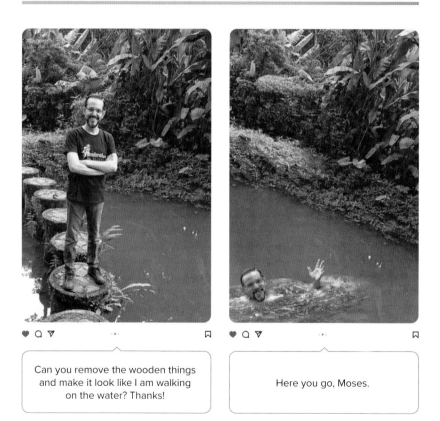

♥ ♀ ⩗ · · · ◰

Can you remove the wooden things and make it look like I am walking on the water? Thanks!

♥ ♀ ⩗ · · · ◰

Here you go, Moses.

TOP KITE

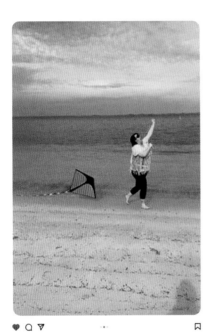

Hi James, can you please make my dreams of flying a kite properly a reality? It just doesn't want to fly!

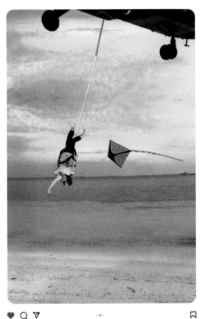

Take it easy!

TAKE OUT THE TRASH

Hey James, can you add a bag on my right hand?

Thank you!

COULDN'T HOLD IT IN

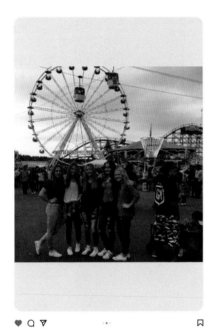

I really like this picture but could you make it so the guy on the right doesn't look like he's peeing on his kids? Thanks.

Fixed.

SHORT SHORTS

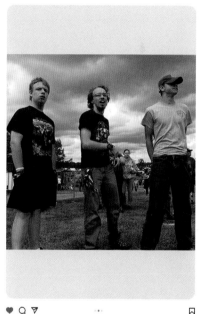

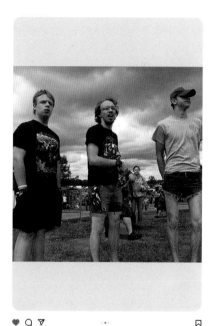

James! I need your help! My family and I went to a concert and I wore obnoxiously short shorts. My legs completely ruined this awesome photo! Please help!
(I'm the ginger on the left.)

You're good.

THE INVISIBLE MAN

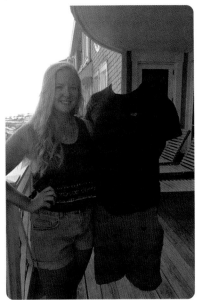

Hey James! Can you crop him out of this without it looking too obvious?

Cute couple.

HIGH SCHOOL'S A WARZONE

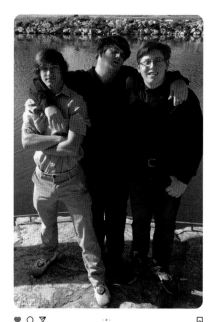

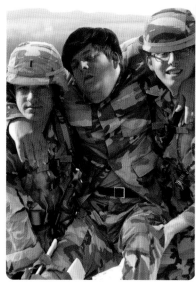

Hello! My friends and I were taking Senior pictures by the river and this ended up looking like they were carrying me while I was passed out drunk. Can you fix this please? Thanks!

Hang in there, pal.

LADY IN RED

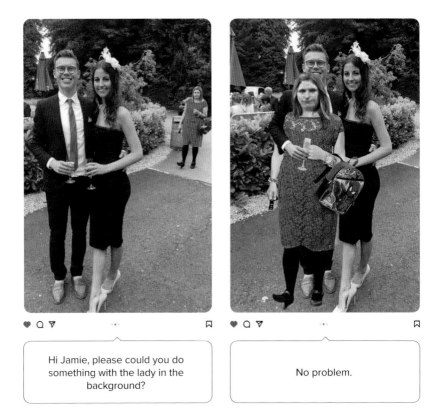

Hi Jamie, please could you do something with the lady in the background?

No problem.

STAY CLASSY

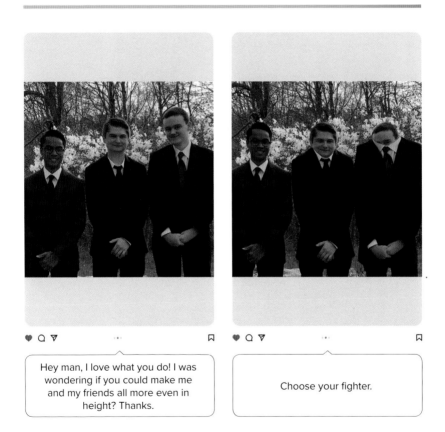

Hey man, I love what you do! I was wondering if you could make me and my friends all more even in height? Thanks.

Choose your fighter.

THE NEVER-ENDING CORN DOG

Hey, just wondering if you could edit this photo of me and my boyfriend. I was hoping you could make his corn dog whole again... with no bites taken out... thanks!

Done.

FRIENDS FOREVER

Hey James, my friend is mad that I (the blonde in the middle) looked at my other friend in this picture and not her. Can you edit it so I'm looking at the girl in the white?

Friendship goals.

MISS LEAVER

Hi Jamie, I taught my class a lesson recently about how some images in the media have been digitally altered and we discussed how these images can then have a negative impact on how people feel about themselves. I showed them some of your amazing work and how you make light of this social issue. They loved it and asked me to send you an image because they would love to see some of your handiwork first hand.
So if you have a chance, as requested by my class, please could you alter the attached image of myself and turn me into a "super cool" teacher?!
Thank you! Miss Leaver.

The fact that you help children to consume media mindfully and selectively makes you a "super cool" teacher already.

PERFECT CURVES

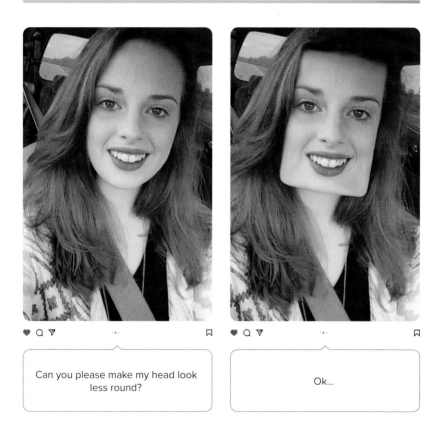

SAY CHEESE

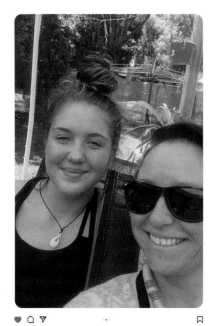

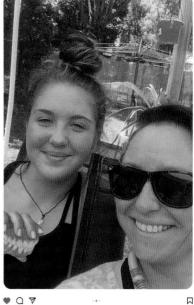

Can u make my sister have her teeth showing while smiling?

Denture wish your girlfriend was hot like me?

JURASSIC LOVER

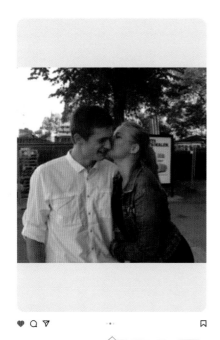

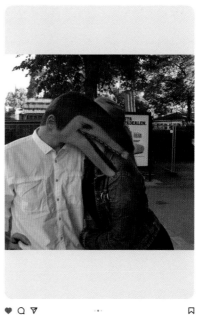

Could you make it look like I'm kissing a dinosaur instead of the guy in white? A Utahraptor would be nice but I'm not picky.

Ju're a great couple!

PLASTIC FANTASTIC

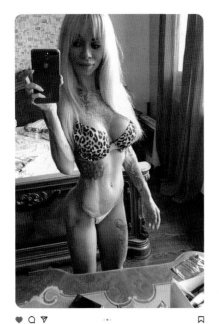 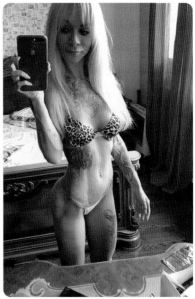

Hey James! Can you please remove that plastic thing from my photo? xxx

Sure.

CHEEKY MONKEY

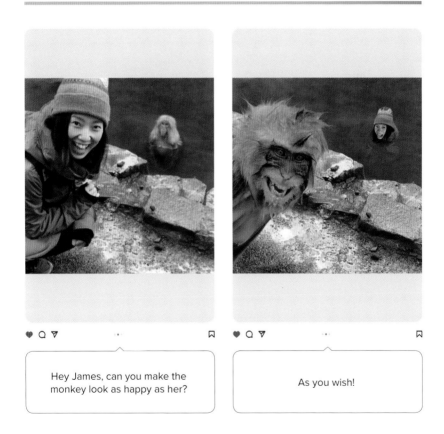

Hey James, can you make the monkey look as happy as her?

As you wish!

HOLD ON TIGHT

Hey James, could you please help me, I need to correct this, it seems I'm holding the hand of my friend.

Looks leg-it.

UNITACHE

Hey... can you put to my face a mustache?

Pablo Escobrow.

DADDY ISSUES

Can you make me look more "Daddy"?

Hey Dad, I'm hungry. Hi Hungry, I'm dad.

BRIGHT IDEA

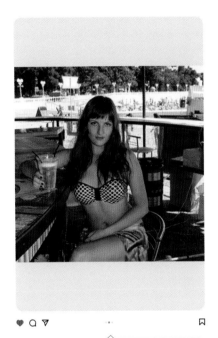

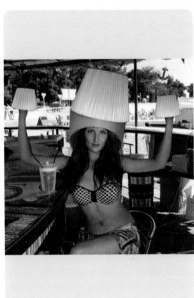

Hi James! Can you please put shades on me, so that I look fierce? Thanks.

Have a bright day.

HER DRESS, HER CHOICE

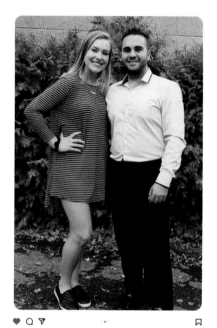

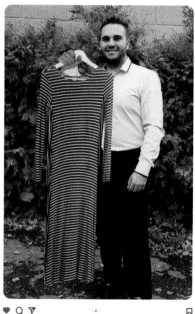

Hey James, love your work. Do you mind making her dress a little longer? I think it's too short. Thanks a lot.

Now find someone to wear it.

LITTLE MERMAID SHOCK TWIST

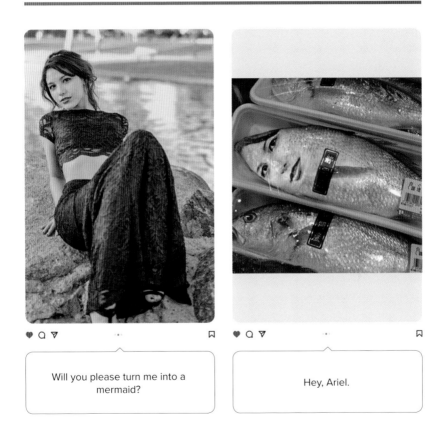

Will you please turn me into a mermaid?

Hey, Ariel.

SUPER SNEAKY

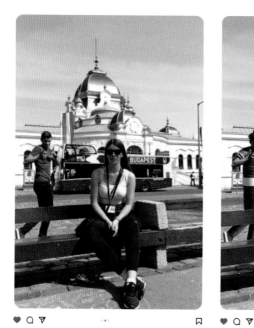

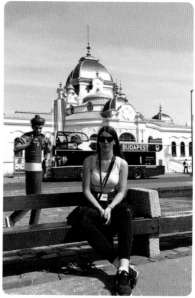

Hello James, I really like your work, so I want to ask you can you do something with this man behind me? He's ruined my photo. Thank you!!

What man?

SCARS

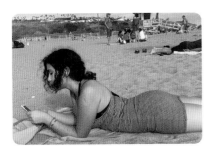

♥ ◯ ⊽ ·· ◻

Hi James,
I started self-harming at the age of 13. I'm 18 now and have been clean for a while. The issue is, I've been suffering for so long that I haven't seen my arms looking "clean" since I was a kid. I want to see my arms without scars. I understand what you do is mostly comedy and it's not your job to do this. But if you ever have the time, I'd love to see my scars removed. This is one of my favourite pictures of me, but it kinda got ruined by my arm. I know I'll have scars for the rest of my life but it would be nice to get rid of them just for one photo.
Thank you so much!

♥ ◯ ⊽ ·· ◻

This method of dealing with stress will always have visible physical consequences followed by deep re-grets. As a young girl you were able to overcome something extremely traumatic and painful, something that you should never have had to live through as a child.
Look at your scars as a constant reminder of how strong you really are. Stay strong. Stay healthy.

WASHBOARD CHIN

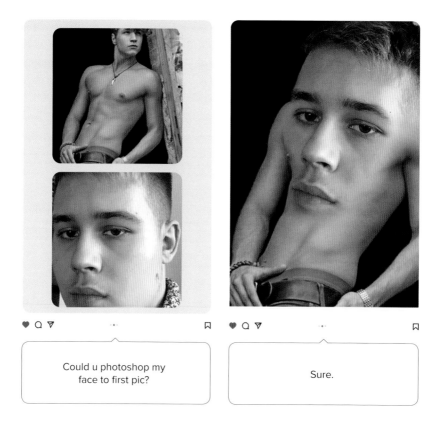

Could u photoshop my face to first pic?

Sure.

CALL THE EXORCIST

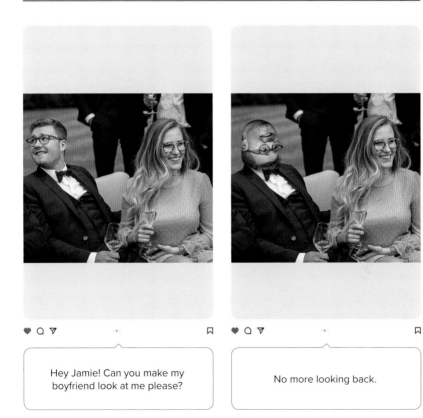

Hey Jamie! Can you make my boyfriend look at me please?

No more looking back.

IT'S A COVER-UP

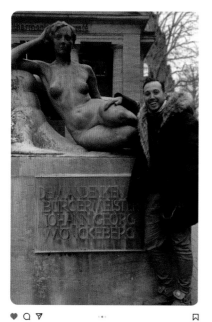

Hi James, my mom is a bit religious and I would really like to show her this picture from my trip to Hamburg, Germany. Can you please cover the naked statue!

Like mother, like son.

HOLDING HANDS

Hi James, could you make it look like me and my girlfriend are holding hands to make this pic look a little less awkward? Thanks.

You got it.

TOO TEMPTING

Hi James! Could you please make the cows a little closer?? Thanks!

Done.

IRONWOMAN

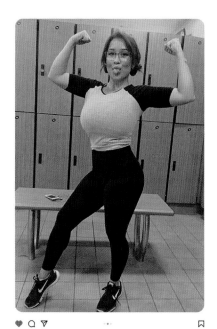

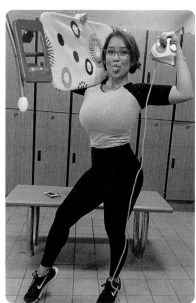

Hi James! Is there any way you can make my shirt not look so wrinkled? It takes away from me showing off my slim waist. Thanks!

Try this.

IT WAS LOAD BEARING

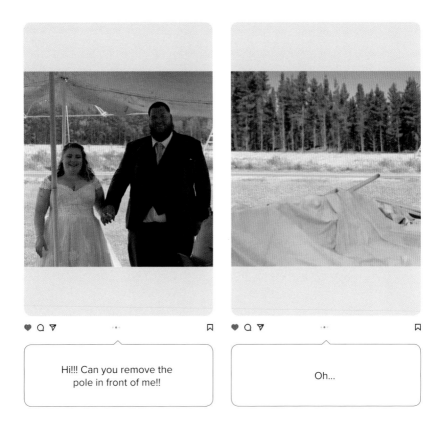

DON'T GO CHASING WATERFALLS

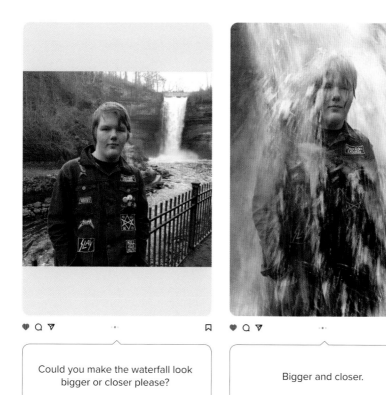

Could you make the waterfall look bigger or closer please?

Bigger and closer.

MADE FOR EACH OTHER

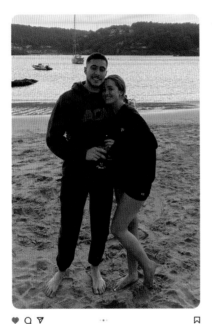

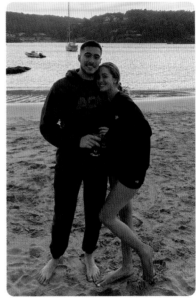

Hi James, can you make it so my boyfriend's feet don't look so long in this photo?

Happy feet.

PERFECTLY FRAMED

Hi, could you edit it so I'm in the frame too? Thanks.

Say cheese.

CRISP AND TASTY

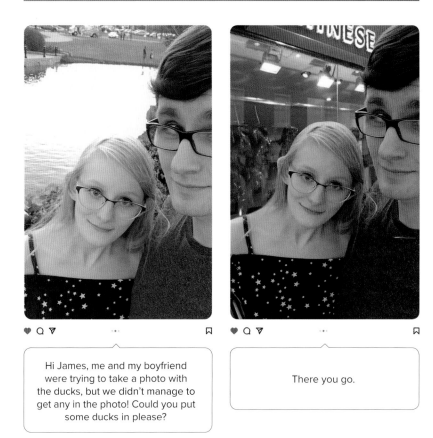

Hi James, me and my boyfriend were trying to take a photo with the ducks, but we didn't manage to get any in the photo! Could you put some ducks in please?

There you go.

JEWPETER

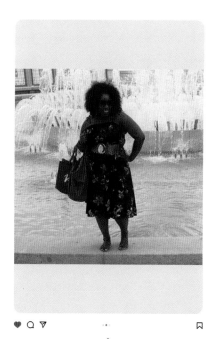

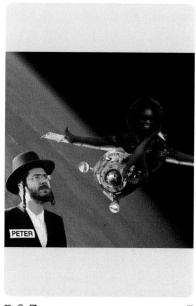

Yo Jamie! Dis my cousin can u put her on spaceship or sumthng and make her look like she flyin to jewpeter or mars thhanx fam!

Safe journey!

EMOTIONAL RESILIENCE

Hi James, I was just wondering if you could edit out my chin. A lot of people make fun of me because of my chin, they call me names like "butt chin guy" and "double chin guy", it really hurts when they say that. I just want one picture with me without my split chin. You probably won't see this as you probably have better things to do but I hope you see it! Thx I'm a big fan!!!

Playful teasing can get rough, but most of the time it's not meant to hurt feelings. Changing your physical features is not a solution, try building emotional resilience by simply laughing it off. Don't take those comments seriously. Sometimes people hurt others because they are hurt themselves.

LONE LURKER

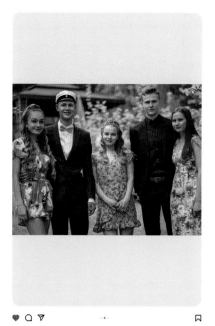

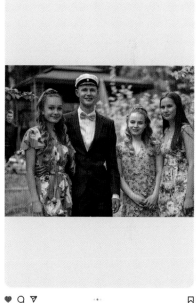

Hi! I found a great shot of me but there are other people around me. I'm that guy on the right. I would like to get a picture where I'm alone.

You must be fun at parties.

THE BEST ONE

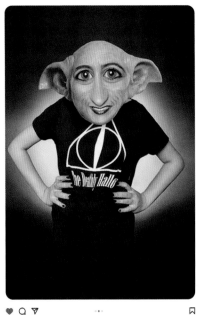

Hey James, I really like Harry Potter. Can you photoshop me like I am a Harry Potter character?

Dobby has come to protect.

HOLD THE POLE

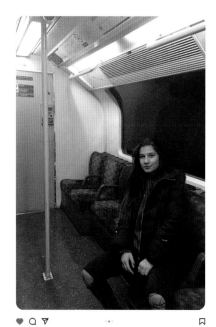

Hey James, my hands look weird, can you make it look like I'm holding the pole instead?

Sure.

EXPERT FISHERWOMAN

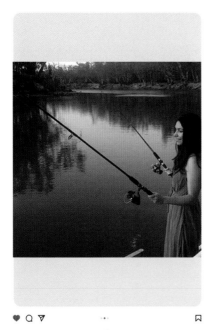

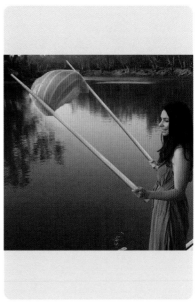

Hey dude, can you make it look like my girlfriend has caught a fish? Cheers, mate!

Nice catch!

CLEAN AND CLEAR

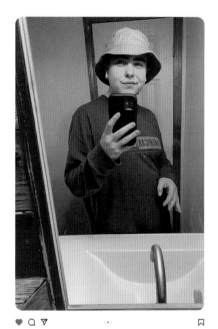

Hey James, can you make the mirror look crystal clear?

Done.

SHOE SALESMAN

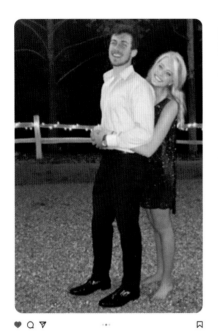

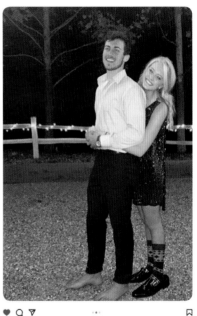

Hey James, my girlfriend forgot to wear shoes in our photo. Could you help?

Barefoot therapy.

UP CLOSE AND PERSONAL

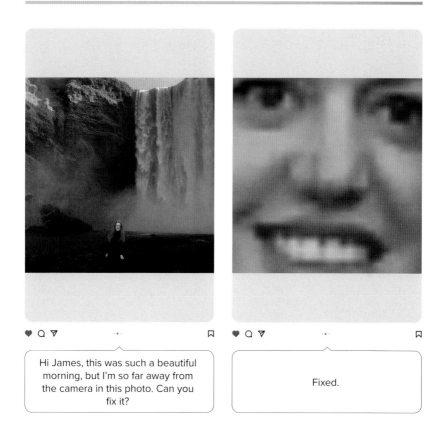

Hi James, this was such a beautiful morning, but I'm so far away from the camera in this photo. Can you fix it?

Fixed.

A WHOLE NEW WORLD

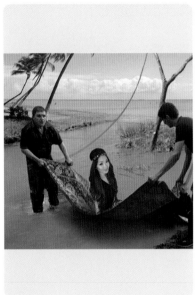

Hey James, can you remove the bed and make me sit on a flying magic carpet flying over an ocean? Lol

Buckle up.

KEEP DIGGING

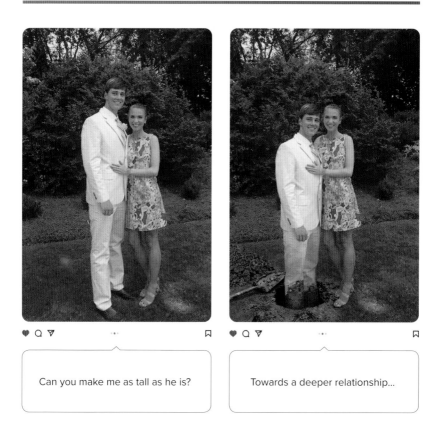

Can you make me as tall as he is?

Towards a deeper relationship...

ERASSED

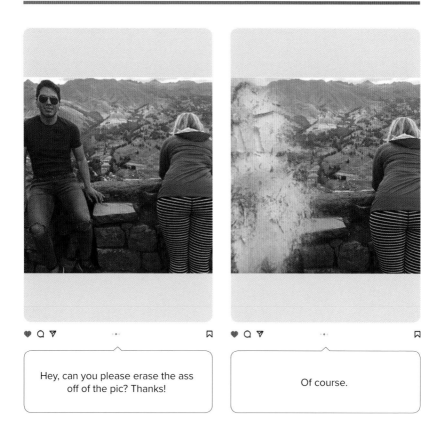

Hey, can you please erase the ass off of the pic? Thanks!

Of course.

THE NAME'S AGENT, ESTATE AGENT

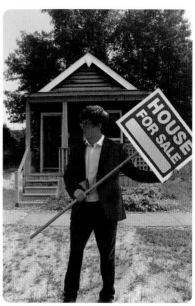

Hi James! I hope you're doing well. I just fired a pistol for the first time, and I was hoping you could make me look like some sort of agent? Thank you!

Not the agent we need, but the agent we deserve.

CHECK THE OPENING HOURS

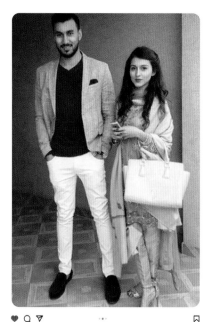

Can you please close my boyfriend's legs?

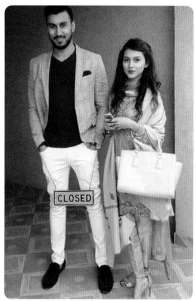

Closed for business.

SKINNY DOESN'T MEAN PRETTY

Hey James! I love your work! You're hilarious! And knowing you, you probably won't do this and I know you get this message A LOT but here goes. Ok. So I've struggled with my weight ever since I was like... what 7? I've tried everything to lose weight too! I've done sports, ate healthy, exercises, took pills. LEGIT. EVERYTHING. But I still remain um.... Fat. Please just make me skinny for once it would be a huge favour! I just want to see what I would look like if I was pretty! Thanks!

Skinny doesn't necessarily mean pretty. Don't let the struggle of trying to lose weight take the fun out of your life. Stay active, eat healthy and let yourself be happy just the way you are.

THE REAL HEROES

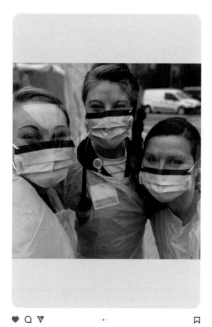

Hey there! How about you doctor up a pic to cheer us doctor and nurses up? What do you say?

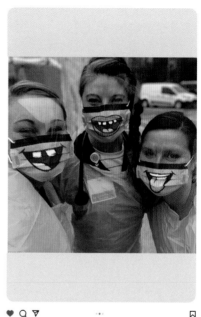

You guys are doing an amazing job!

HANGING FREE

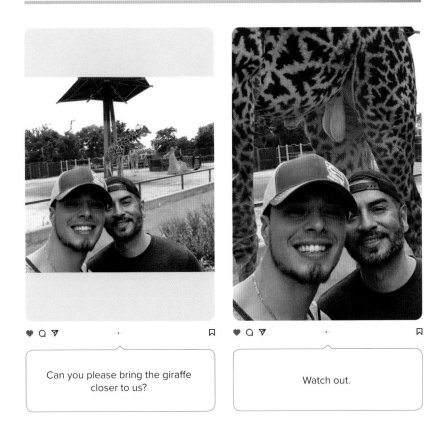

Can you please bring the giraffe closer to us?

Watch out.

HANDS IN HANDS

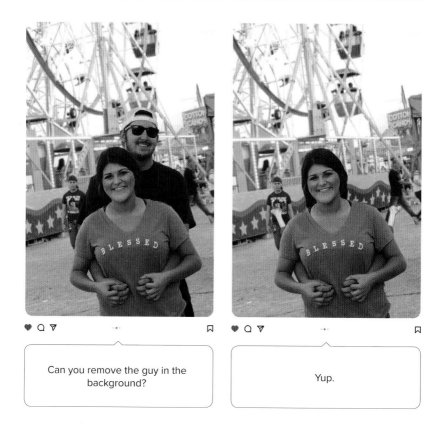

Can you remove the guy in the background?

Yup.

WELCOME TO THE FRIENDZONE

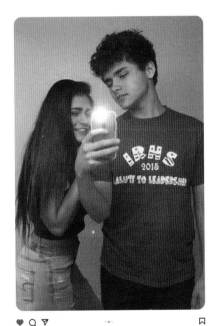

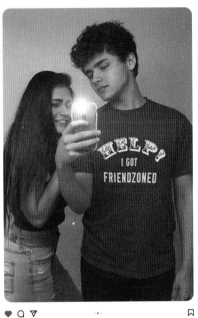

Hi James, my friend looks like he doesn't enjoy my company. Can you make him look like he's having fun? Thanks.

He does enjoy your company.

TIGER QUEEN

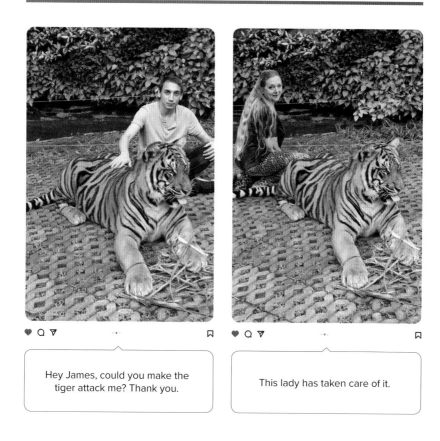

Hey James, could you make the tiger attack me? Thank you.

This lady has taken care of it.

NEVER LET GO

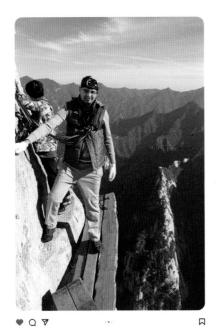

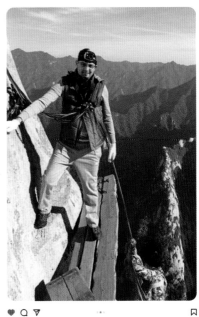

Hey man!!! Can you remove the lady at the back and make the pic look more epic ;)

You are epic.

LOOK CLOSER

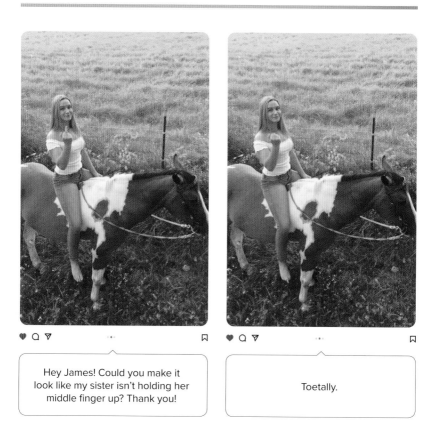

♥ ○ ▽ · • · 🔖
Hey James! Could you make it look like my sister isn't holding her middle finger up? Thank you!

♥ ○ ▽ · • · 🔖
Toetally.

LITTERBUG

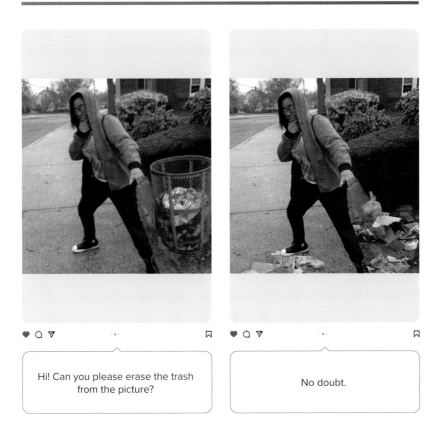

Hi! Can you please erase the trash from the picture?

No doubt.

INHERITED HAIRSTYLE

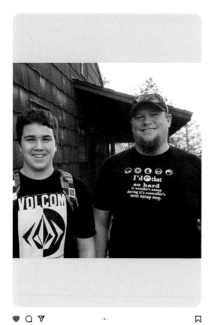
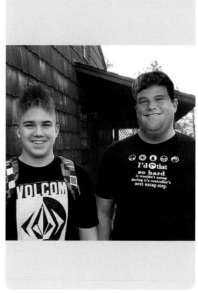

♥ ◯ ✈ ·· 🔖 ♥ ◯ ✈ ·· 🔖

Could you please give my son and I better hairstyles so we look cool?

Rock on.

DO ANYTHING FOR DUCKS

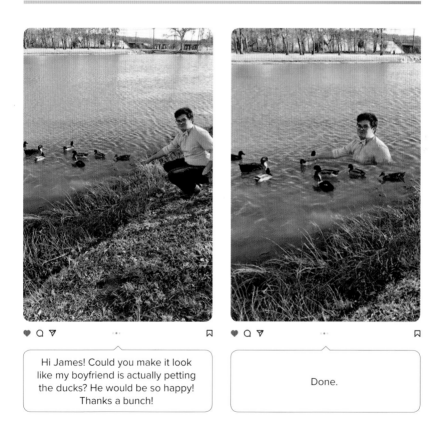

Hi James! Could you make it look like my boyfriend is actually petting the ducks? He would be so happy! Thanks a bunch!

Done.

ONLY ONE WINNER

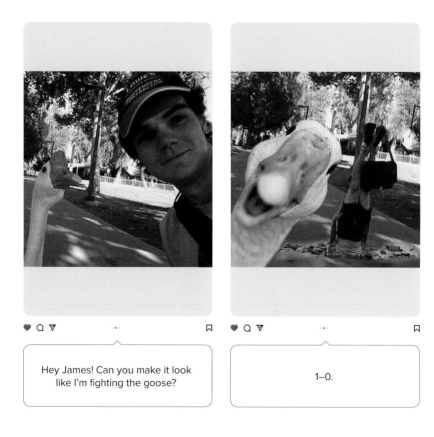

Hey James! Can you make it look like I'm fighting the goose?

1–0.

DINNER FOR ONE

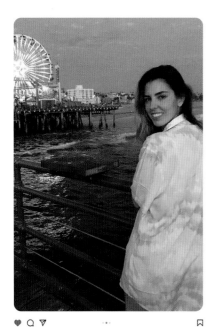

Hi James! I love your work... Could you get rid of the wood thing full of bird poop in front of me? Hahaha thank you! :)

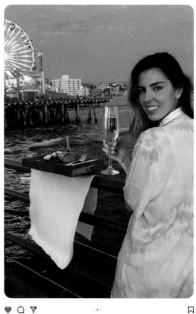

Luxury dining with a view.

ACNE

I have had very bad acne for as long as I can remember and sometimes I just wonder what a clear face would look like. I love this picture and I would like to look at it and remember the good time I had hiking, not my acne... any chance you could get rid of it for me if you have time?

Do not try to change the past. Improve your present, and hurtful memories from the past will become insignificant. Your decision not to hide behind makeup is wise and courageous. With the help of a good dermatologist and appropriate treatment, your acne could be improved dramatically, letting your naturally pretty features shine brighter.

HOME UNDER THE HAMMER

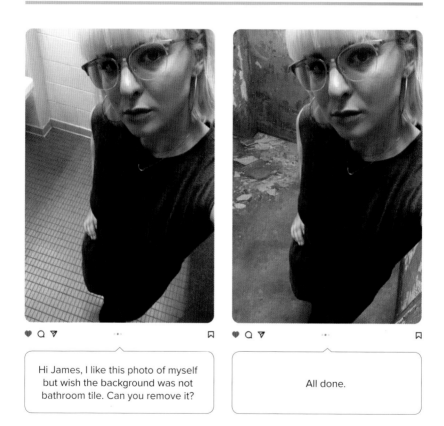

Hi James, I like this photo of myself but wish the background was not bathroom tile. Can you remove it?

All done.

BEACH BODY READY

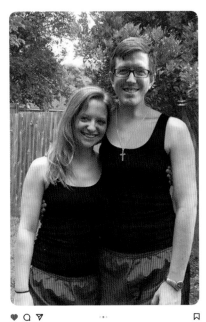

Hey James, could you give me a summer body to go along with my wife's beautiful features? This is the best option I have until I can afford a gym membership. Thanks in advance.

There you have it.

TWIN PEAKS

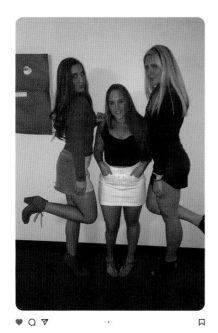

Can you make my friend in the middle the same height as us?

BFG: Big Friendly Girlfriends.

THE GREATEST BOXER EVER

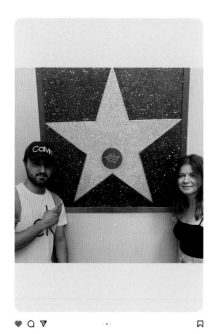

Hi James, my boyfriend is a fan of Muhammed Ali. Could you make him as a boxer? Thank you!

The best boyfriend ever.

SUNLIGHT IS THE BEST DISINFECTANT

Hey James, there was a lot of sunlight when we took this picture and my boyfriend looks like he's crying. Can you fix it?

It's not the sunlight.

MADE TO MATCH

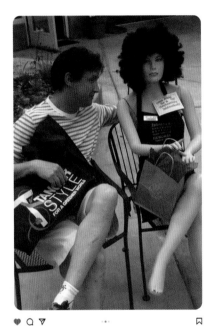

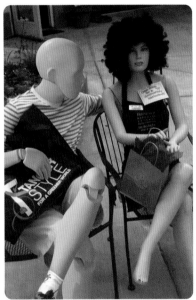

RICH BEYOND YOUR WILDEST DREAMS

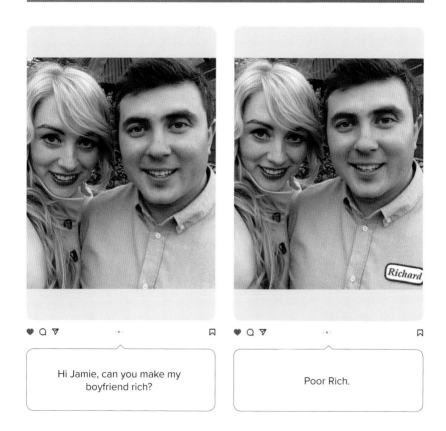

Hi Jamie, can you make my boyfriend rich?

Poor Rich.

THINKING A-HEAD

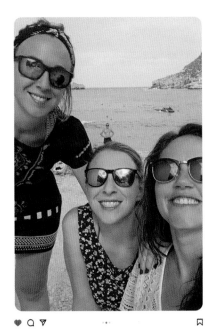

It seems that I have a boy in my head, can you remove it?

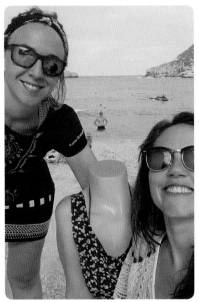

Sure, that's a no-brainer.

BOBBLEHEAD

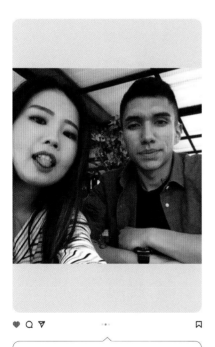

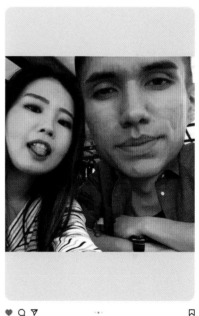

Hey James! Can you make my face smaller than my bf?

Done.

THE WORLD CHAMP

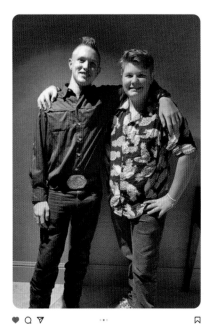

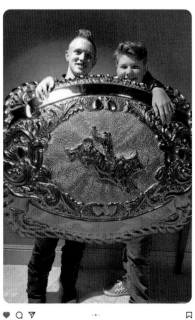

Can you make my belt buckle bigger?

There you go, partna'.

INFINITY POOL

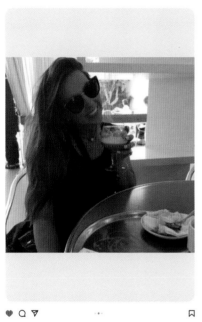

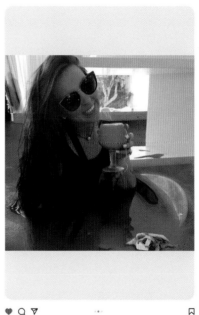

Hey James! Do you think you can make it look like I'm holding a full glass of coffee instead of how it is? Thank you!

Say when.

POCKET PROTECTOR

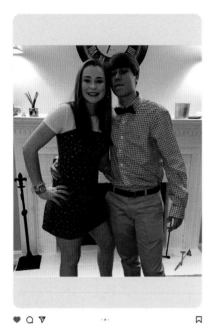

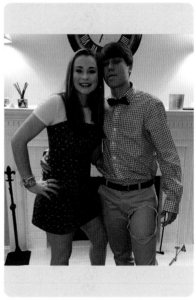

Hey James you're amazing at editing. I was wondering if you could make the phone in my pocket disappear. It's really noticeable. Thanks!

Of course.

MUSCULAR DYSTROPHY

Hi! I have muscular dystrophy and can't straighten my arms. Can you make me look more normal in my homecoming picture? Thanks!!!!

Acceptance of your true self can be a constant battle. The term "normal" is a propaganda technique used by the modern society to make us conform to a pre-existing standard. If people can't look past your physical condition, they are most likely not worth your attention. A pretty young girl with a genuine smile and beautiful hair is all I see in this picture.

BODY PERFECT

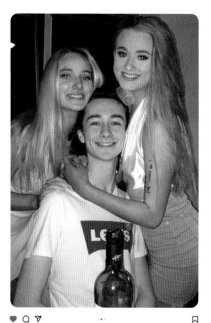

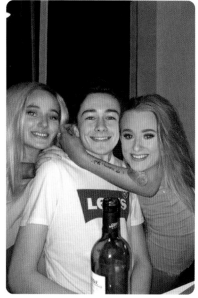

Hey James!! Can you edit this so we're all the same height please?
xxxxxx

Ok.

DROP HIM

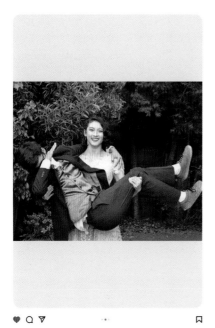

Hi James, I want to post this prom photo of me and my friend but he's dabbing. Could you photoshop it so that he's not dabbing anymore? Thanks!

He's not dabbing anymore.

GROWING PAINS

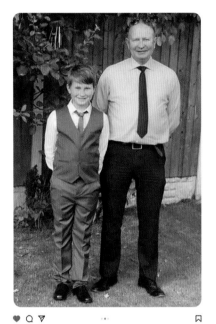

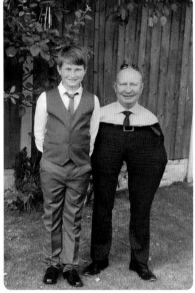

Can you make me taller than my dad plz?

Vladimir Tuck-in.

SMOOTH CRIMINAL

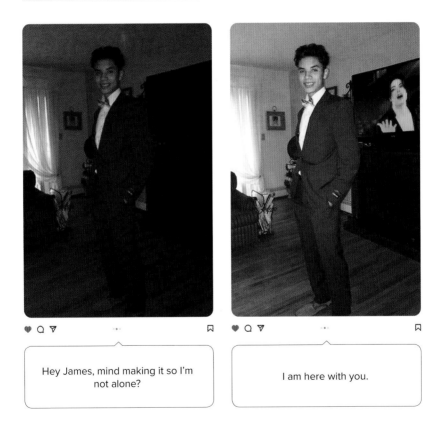

Hey James, mind making it so I'm not alone?

I am here with you.

FAMILY PORTRAIT

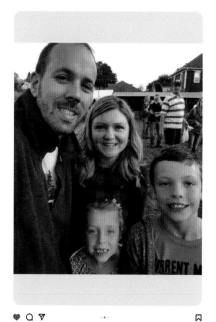

Can you make it look like the striped shirt guy isn't staring at the back of my head? I'm the dad.

Hey, pal.

GRADUATING UPWARDS

Hi! My friend took some photos for his graduation and in one of the photos his legs look kinda weird, can you move them a little closer?

A little closer to what?

I SEE THROUGH YOU

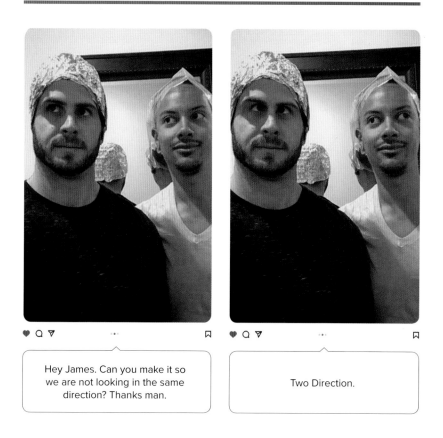

Hey James. Can you make it so we are not looking in the same direction? Thanks man.

Two Direction.

BENCH FRIENDS

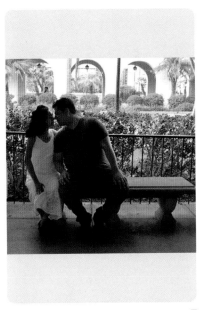

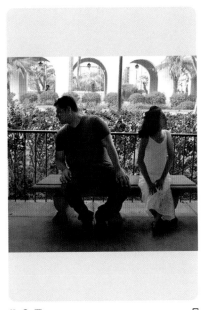

Hi James, I was wondering if you could make it look like I'm not sitting on the edge of the bench? There were several of us sitting down and they stood up but we didn't scoot down.

Sure.

THE REAL DEAL

♥ ○ ▽ · · 🔖

♥ ○ ▽ · · 🔖

Hi Jamie! Someone told me that this picture looks like we're on the set of a *Jurassic Park* movie. Can you put some dinosaurs in this picture please?

Here you go, guys.

WATCH OUT FOR HUNTERS

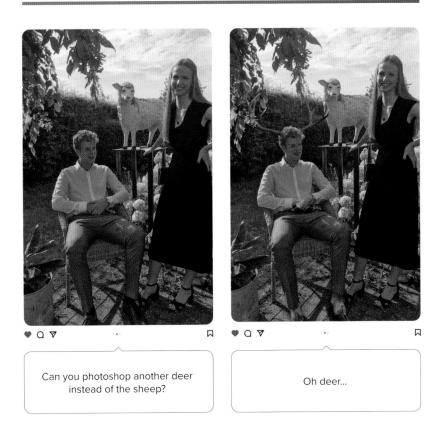

ICONIC

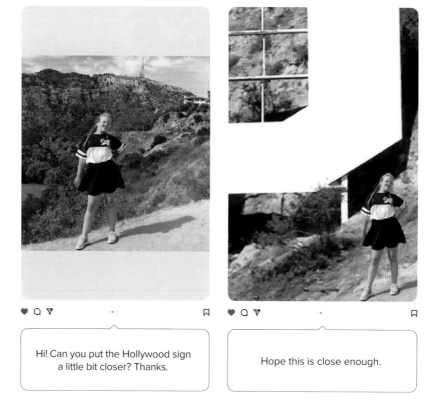

Hi! Can you put the Hollywood sign a little bit closer? Thanks.

Hope this is close enough.

YOU SHALL NOT PASS

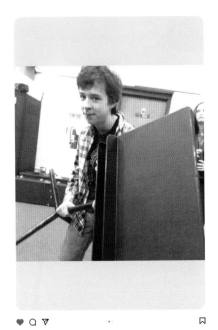

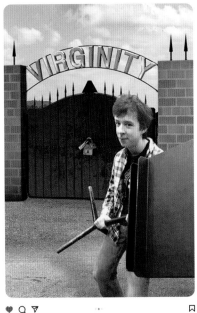

Could you put me somewhere cooler? Perhaps guarding the gates of Hell?

Keep it safe.

TABLE COVER

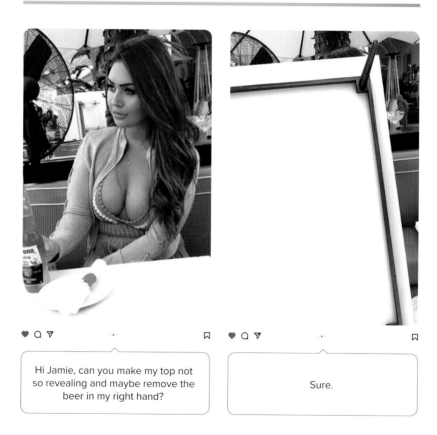

Hi Jamie, can you make my top not so revealing and maybe remove the beer in my right hand?

Sure.

MUSCLE-MAN

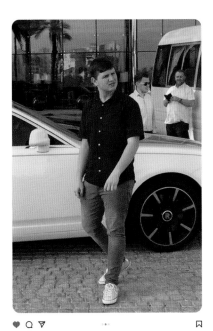

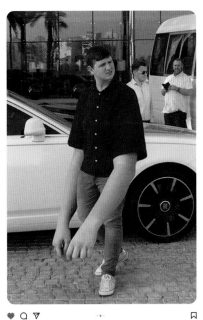

I love your work and I was wondering if u could make my arms look bigger in this picture, thank u!

What a HANDsome guy.

ONE COOL DUDE

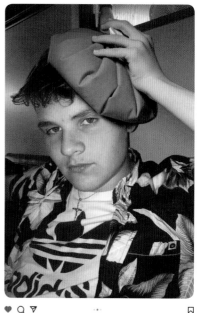

Hey James. I like this pic, but I don't think I look cool enough. You think you could make me look a bit cooler? Thx

How about now?

QUEEN'S GAMBIT

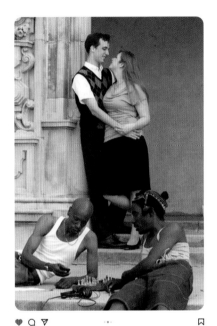

Hi James! This was an engagement picture. I like it, but the guys in front seem out of place. Can you fix it please? Thank you!

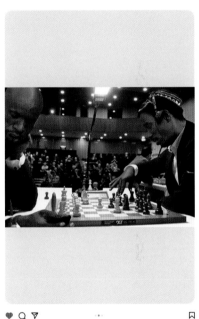

Checkmate.

MATURE GROWTH

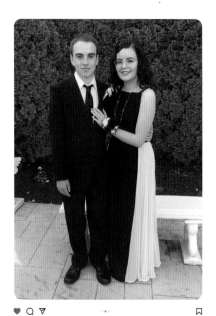

Hi James! Can you please photoshop my ex-boyfriend out of the picture? I wanna post a throwback to prom, but we kinda ended on bad terms and I don't want to start anything if I posted one with him. Thank you in advance!

He grew out of it.

HELPFUL AND INFORMATIVE

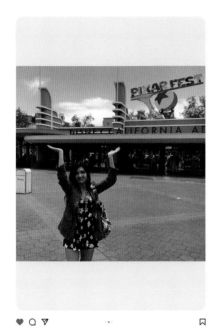

Hey Jamie, I'm loving your work and I was wondering if you could help me out with this photo. Can you fix this so that I'm holding the sign? Thx

Fixed.

TYPOS ARE IMPORTANT

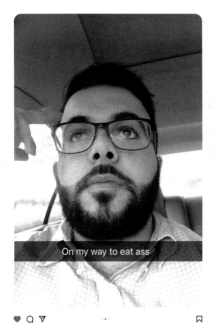

On my way to eat ass

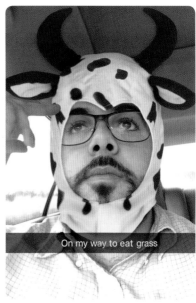

On my way to eat grass

Hey James, hope you're doing well. I am wondering if it's possible to remove the caption from the photo. I appreciate any help or assistance! Thanks so much!

Bon Appétit.

LEG-ENDARY CHAIR

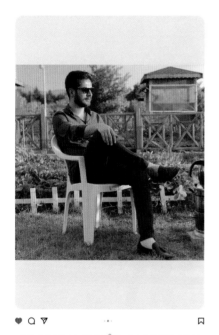

Hi Jamie, can you please fix the chair because it's not aesthetic. Thanks.

Have a seat.

ALL ALONE

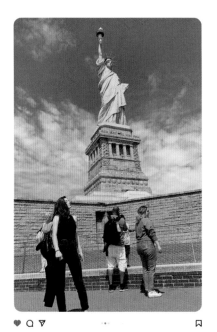

Hi James, can you please get rid of the people in the background?

Done.

A HIDDEN MESSAGE

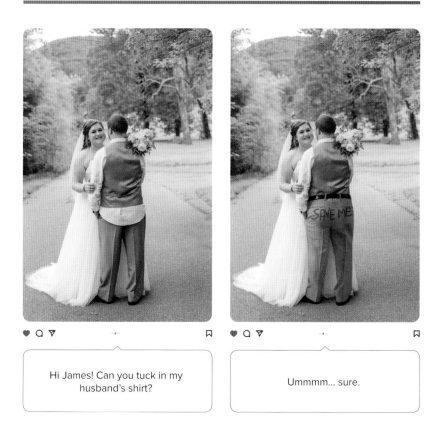

Hi James! Can you tuck in my husband's shirt?

Ummmm... sure.

THAT'S AMORE

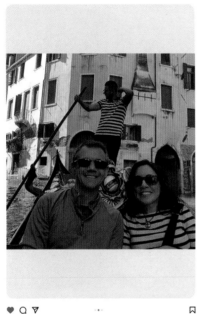

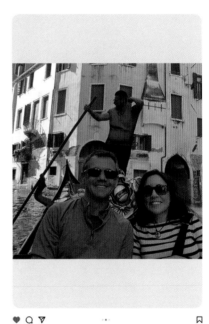

Hi James, I'm hoping you can help. I love this picture of my wife and I in Venice, but she dressed just like the gondolier! Can you fix it so it doesn't look so awkward?

That wasn't VEryNICE of you.

ROMANTIC BEACH GETAWAY

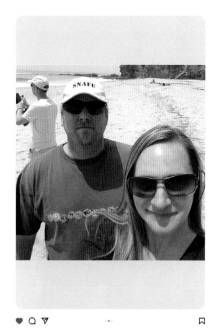

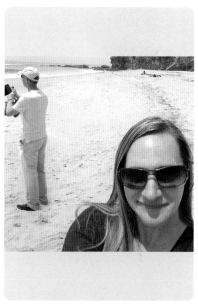

Hi James, I like the picture of my wife and I, but can you get rid of the other guy in the white hat please? Love your work!!

There's always that one guy.

STRAIGHT FIX

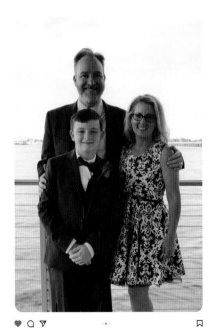

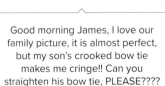

Good morning James, I love our family picture, it is almost perfect, but my son's crooked bow tie makes me cringe!! Can you straighten his bow tie, PLEASE????

No problem, madam.

BE MY VALENTINE

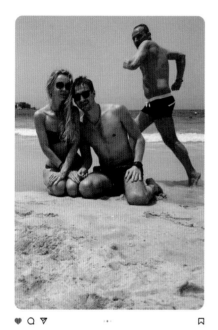

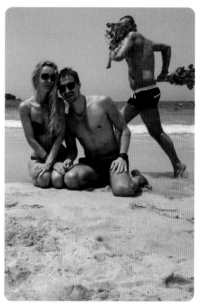

Hi bro! Can you make this photo more romantic please, thanks!

No doubt, bro.

SIGHTSEEING IS THIRSTY WORK

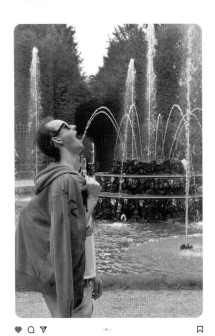

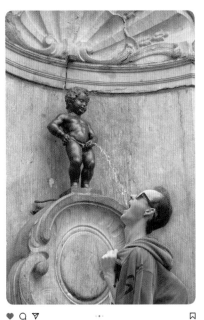

Hey James, could you do it so that the water goes in my mouth in this photo? I would really really appreciate that. Thank you! :)

Wrong fountain.

BACK TO FRONT

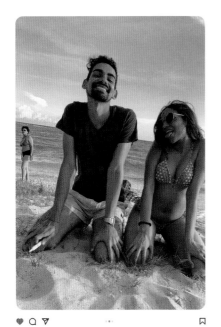

Hey James, could you please remove my friend from the background?

Sure.

PONY UP

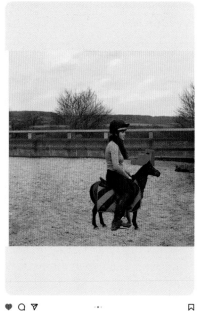

Hey Jamie, any chance you could make the horse smaller or me bigger so I don't look like an ant??? Thanks!!!

Yeehaw.

THUNDERSTRUCK

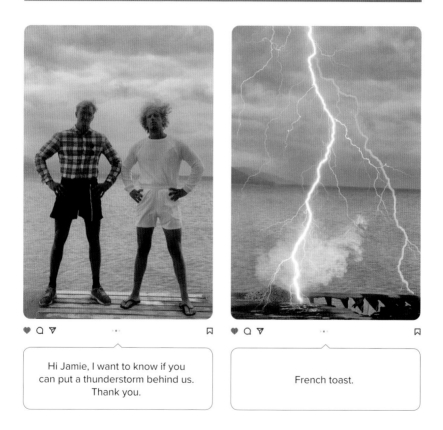

Hi Jamie, I want to know if you can put a thunderstorm behind us. Thank you.

French toast.

About the Author

James Fridman lives in London, but travels a lot. While he's not studying the basics of Photoshop, he spends most of his time working with the James Fridman Foundation to support children and young people affected by social issues. At the foundation, one of the main goals is to create awareness of the importance of self-acceptance among children through various art and creativity projects.

To communicate this vision to a much younger audience, James created Bobli, a genderless creature with imperfections – uneven legs, wonky eyes and a mouth that appears both happy and sad at the same time. Right after Bobli's story went live, children from all over the world started sending heart-warming letters, sharing their daily struggles with Bobli. James is currently working on a Bobli children's book.

www.jamesfridman.com

Twitter and Instagram: @fjamie013

Facebook: @jamesfridmanpage